This book is written by: Michelle Thomas

Photographer: Michelle Thomas

Paperback Edition

Copyright © 2015 Michelle Thomas

Photos are the most precious memorable moments captured with our pupils, which can or will have a lasting effect on our lives.

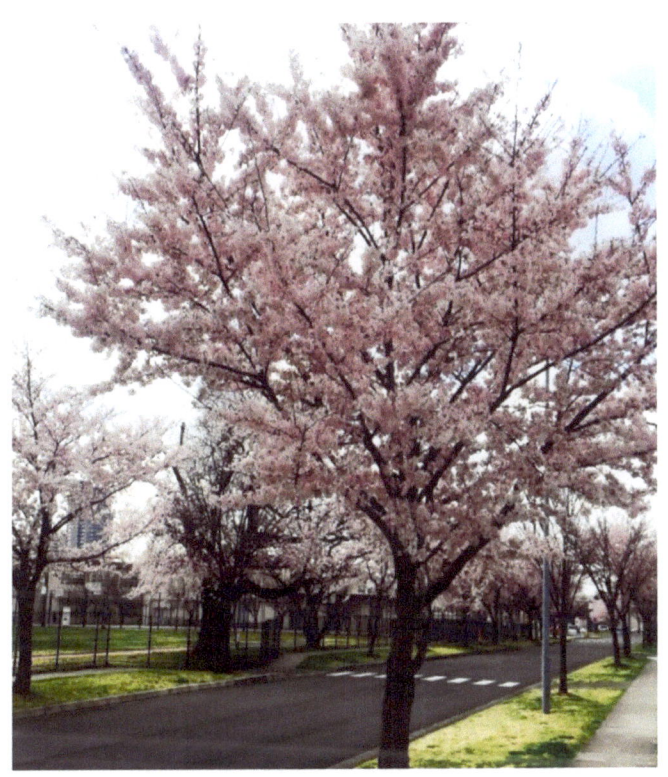

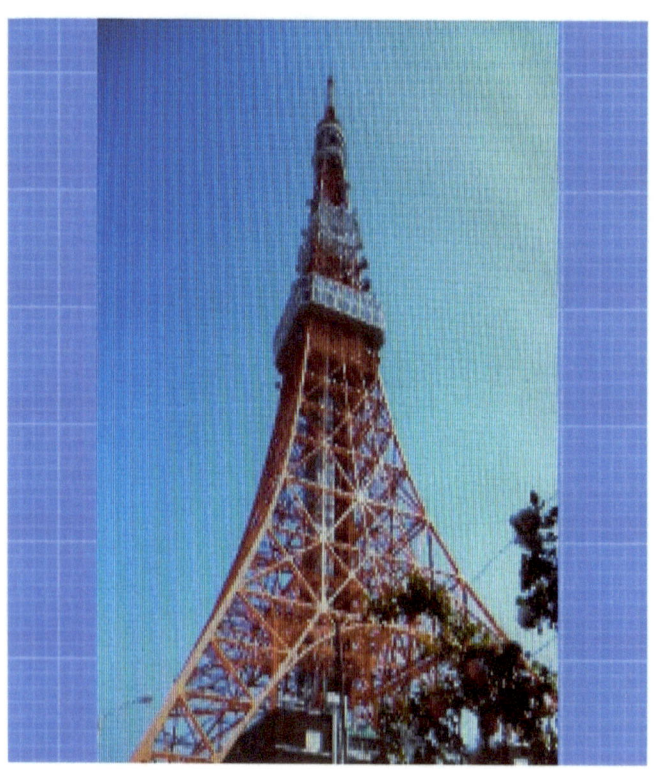

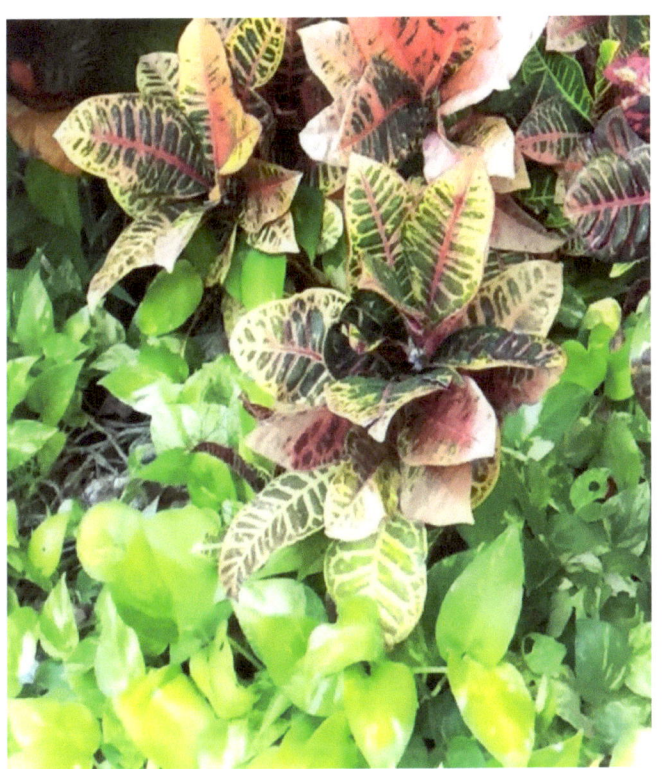

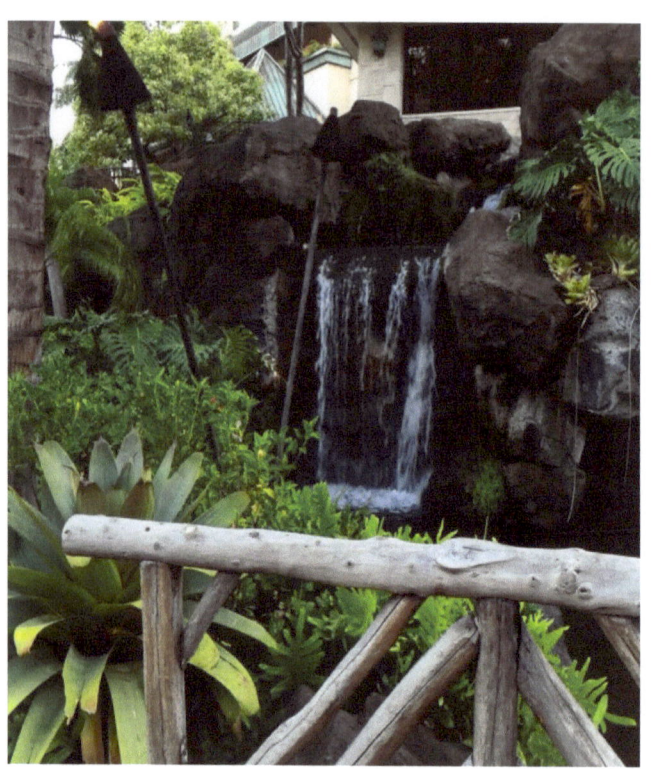

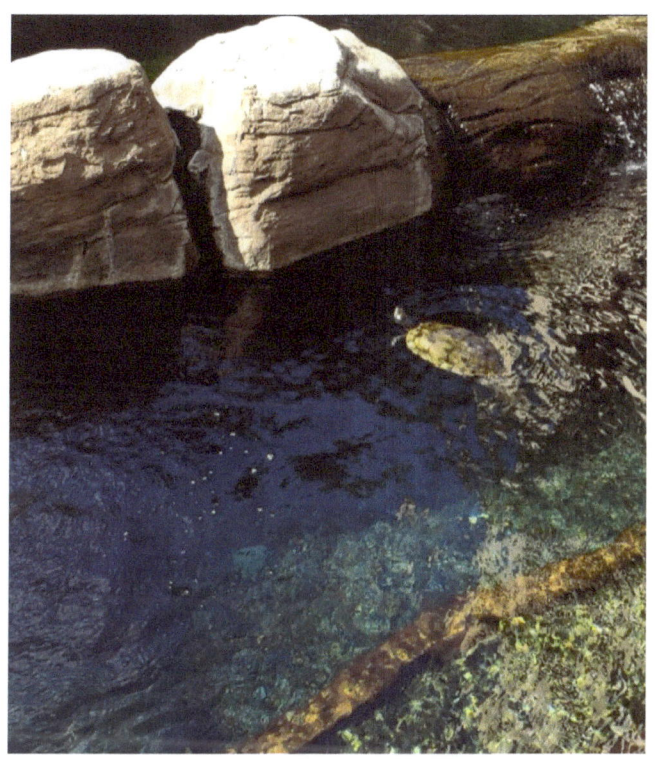

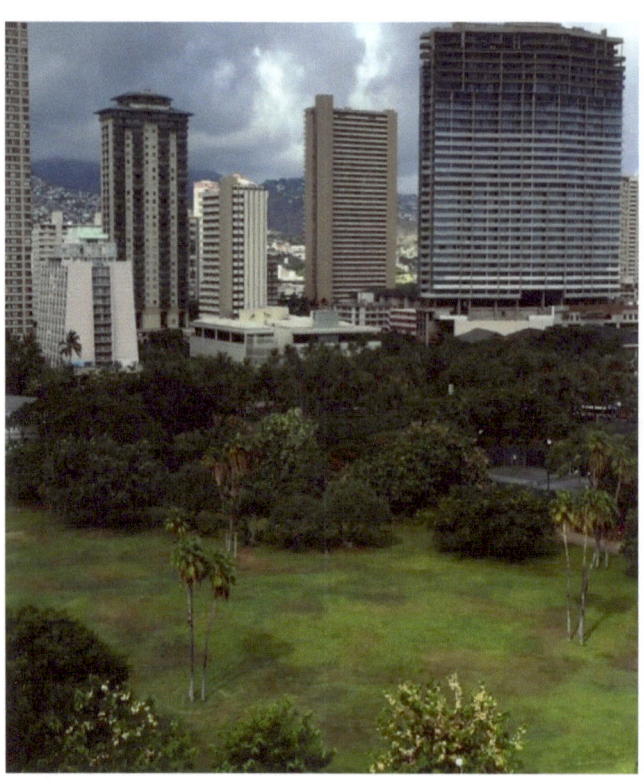

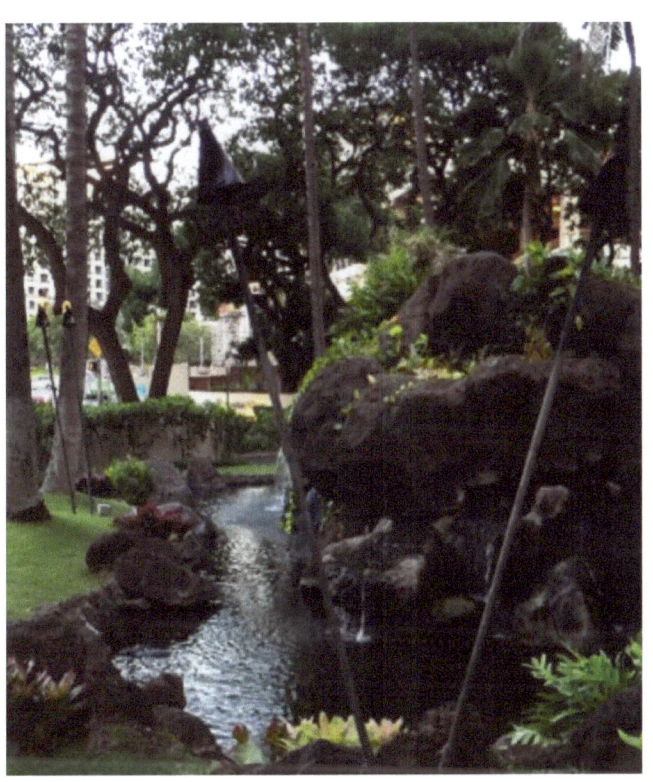

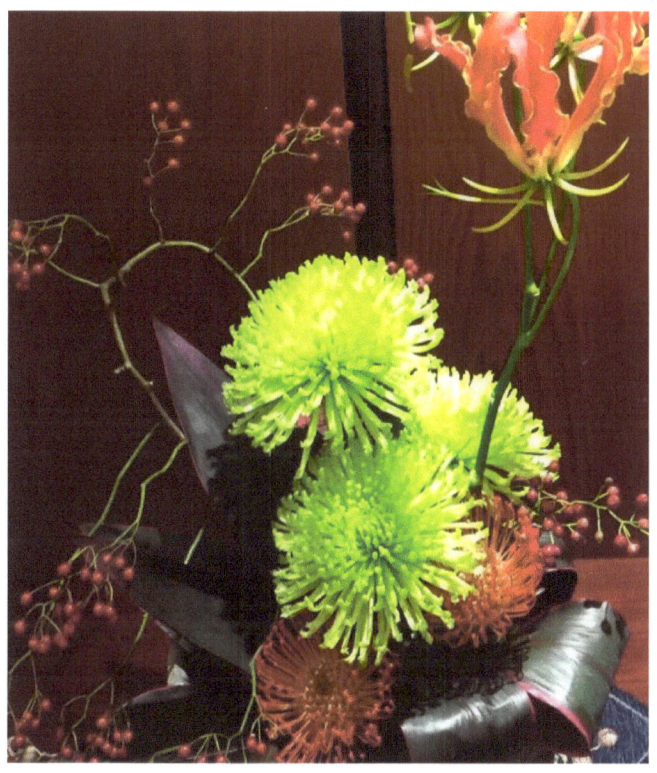

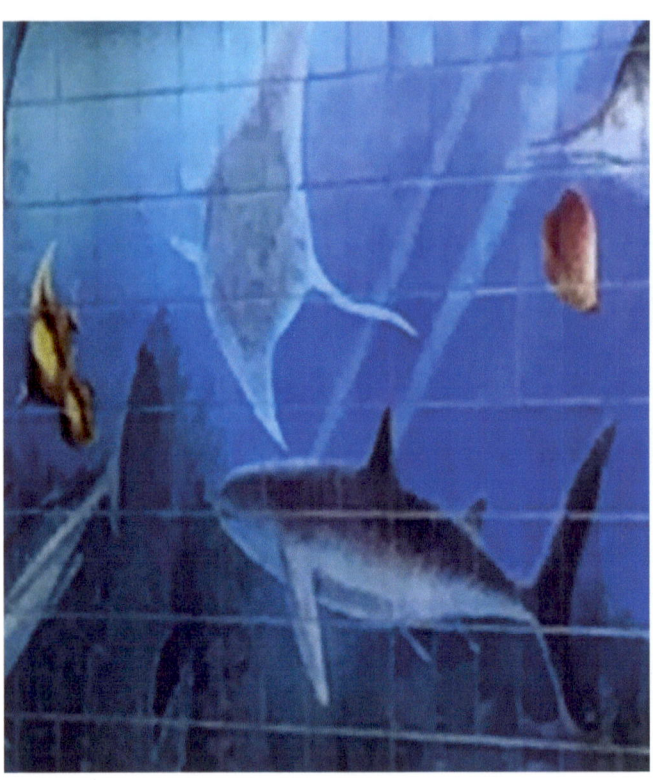

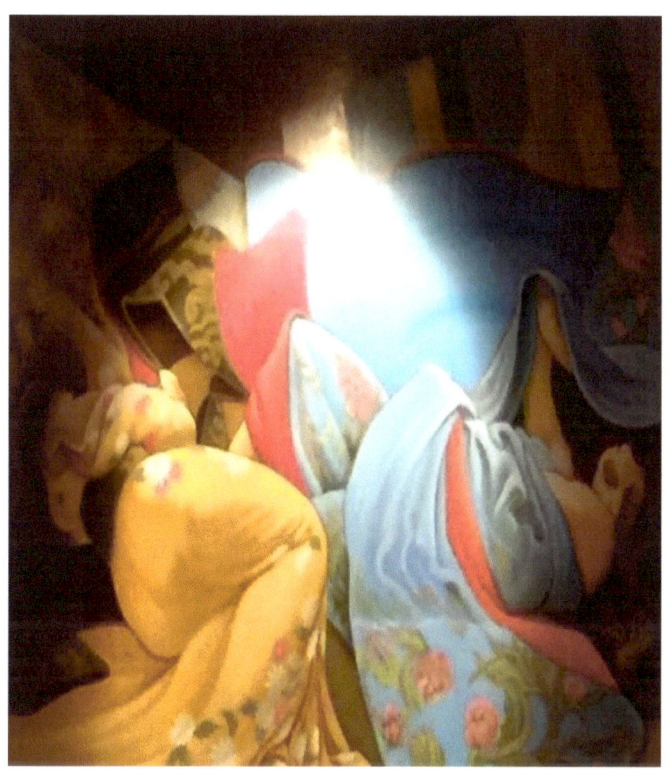

www.ingramcontent.com/pod-product-compliance
Lightning Source LLC
Chambersburg PA
CBHW041612180526
45159CB00002BC/827